The Kiss

Universe Books
New York

Published in the
United States of America in 1976
by Universe Books
381 Park Avenue South,
New York, N.Y. 10016

Library of Congress Catalog Card Number: 76-5091

Cloth edition: ISBN 0-87663-238-X
Paperback edition: ISBN 0-87663-947-3

Picture research by Miriam Friedman
Design by Robert Reed

Printed in the United States of America

Eight Classes of Kisses

The kiss of passion.
The parental and filial kiss.
The kiss of affection (always between women).
The devotional kiss.
The fraternal kiss.
The kiss of curiosity.
The kiss of treachery.
The fleshly, evil kiss.

—Alfred Fowler,
The Curiosities of Kissing

"Stay," he said, his right arm around her waist and her face expectantly turned to him, "shall it be the kiss pathetic, sympathetic, graphic, paragraphic, Oriental, intellectual, paroxysmal, quick and dismal, slow and unctuous, long and tedious, devotional, or what?" She said perhaps that would be the better way.

—Charles Carroll Bombaugh,
The Literature of Kissing

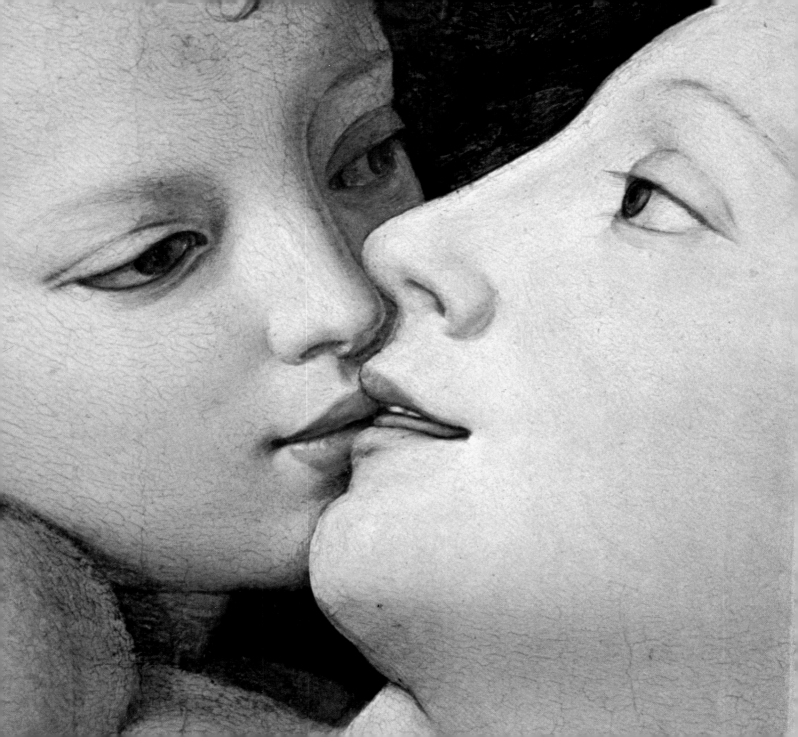

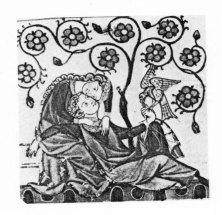

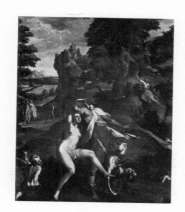

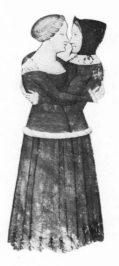

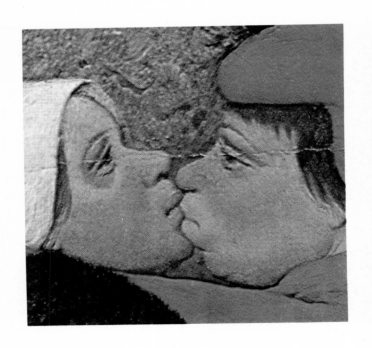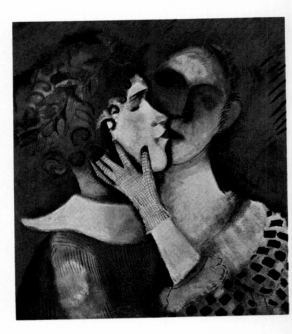

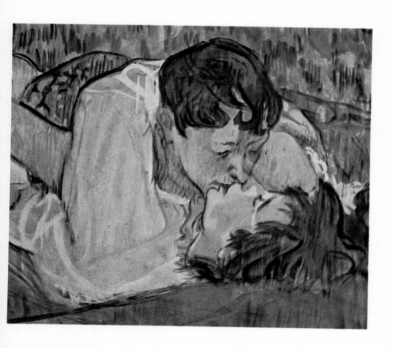

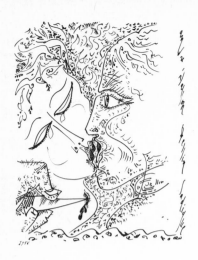

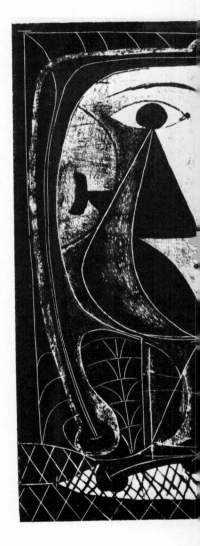

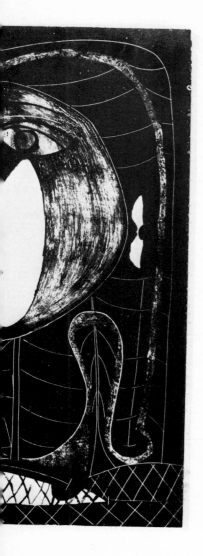

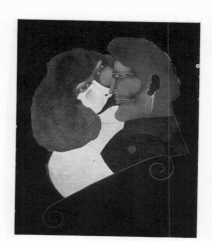

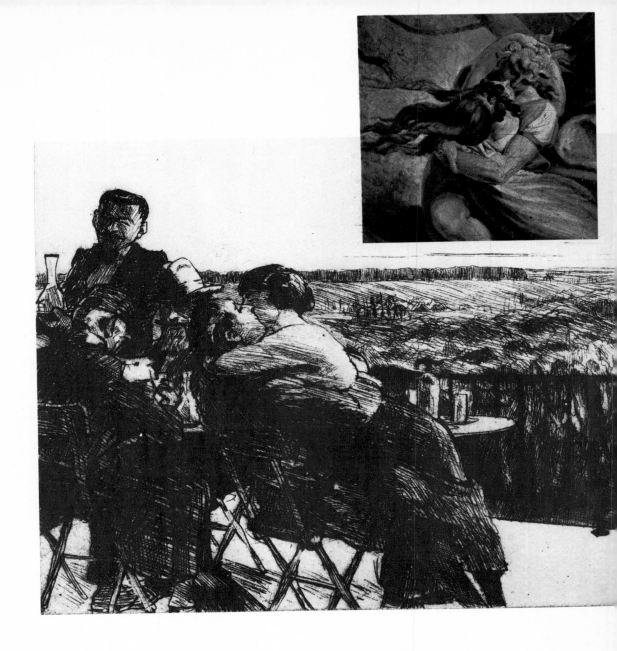

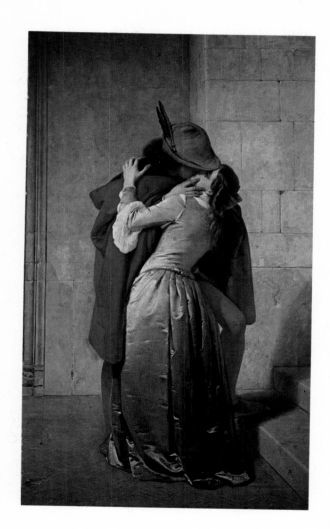

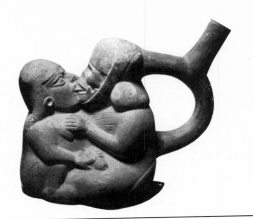

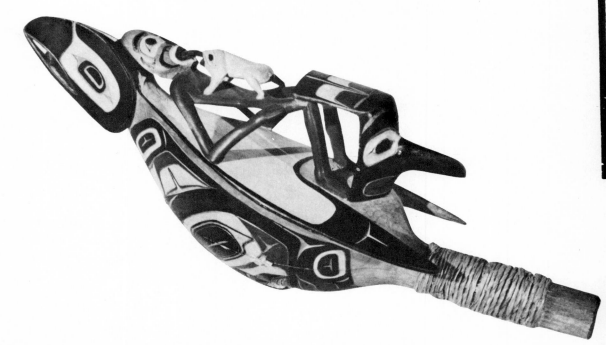

16

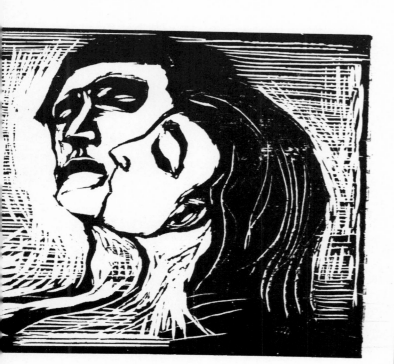

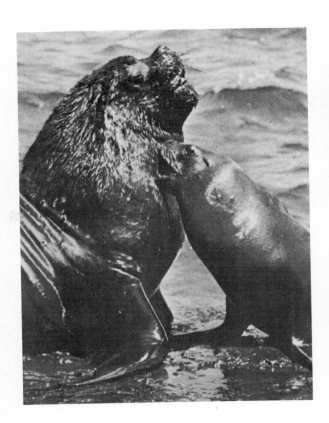

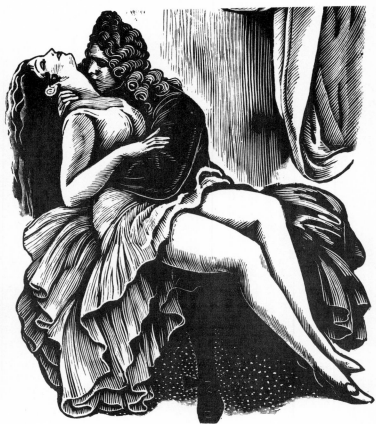

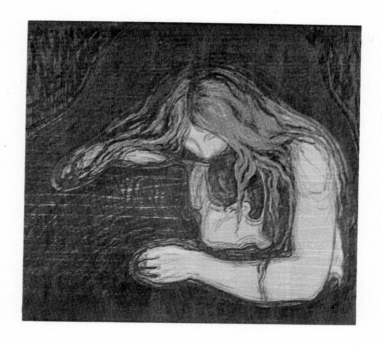

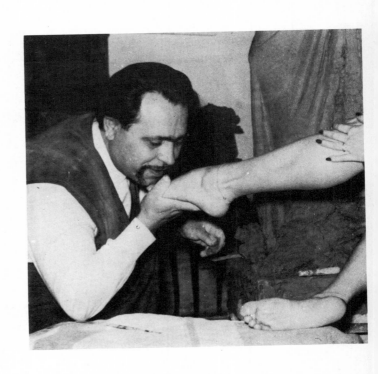

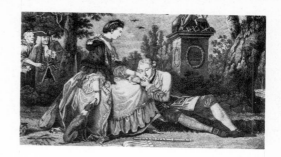

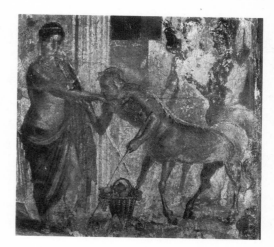

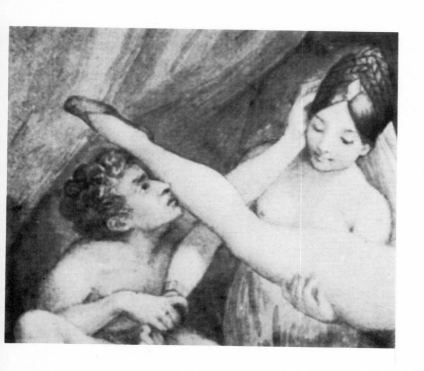

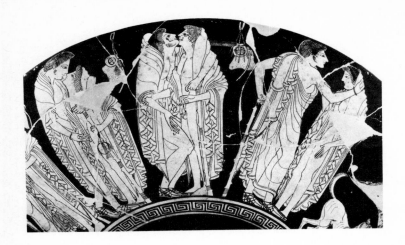

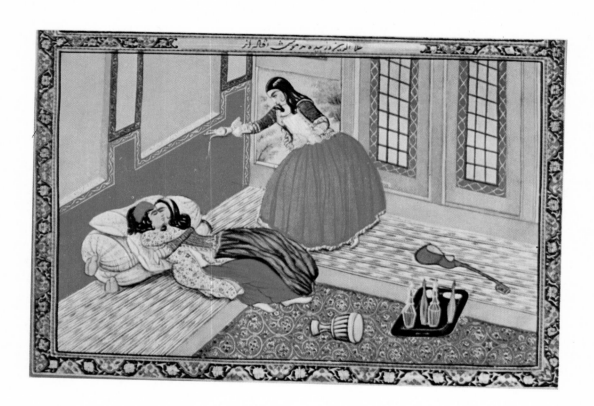

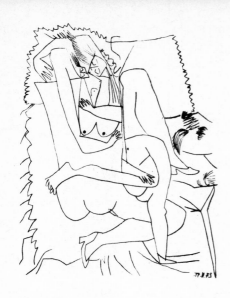

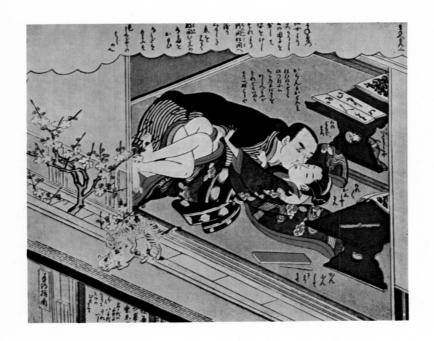

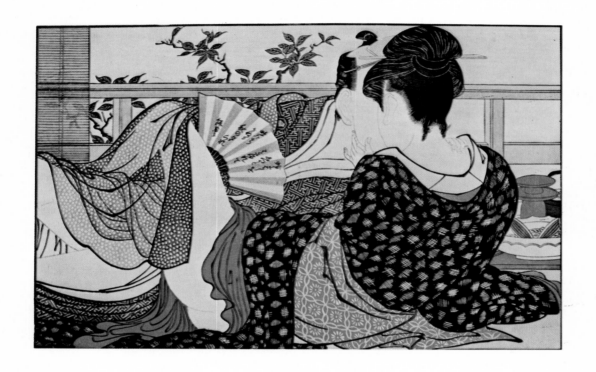

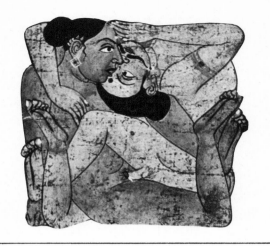

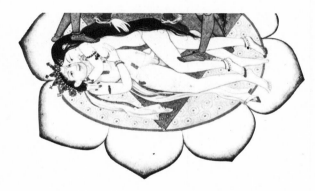

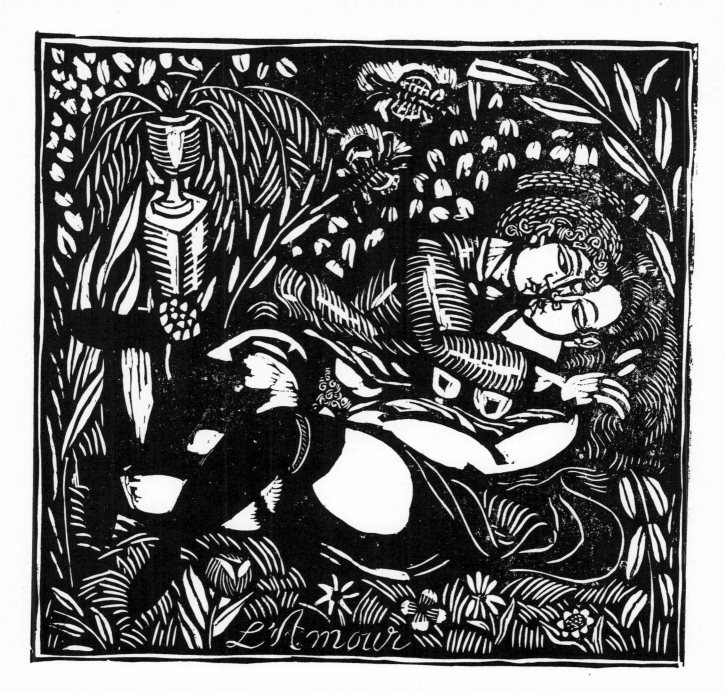

L'Amour

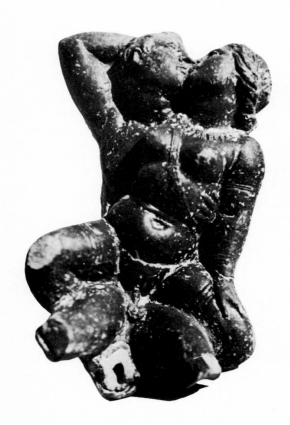

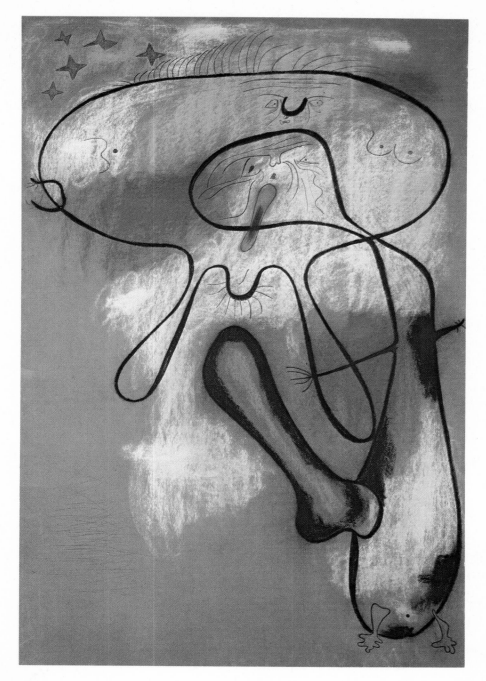

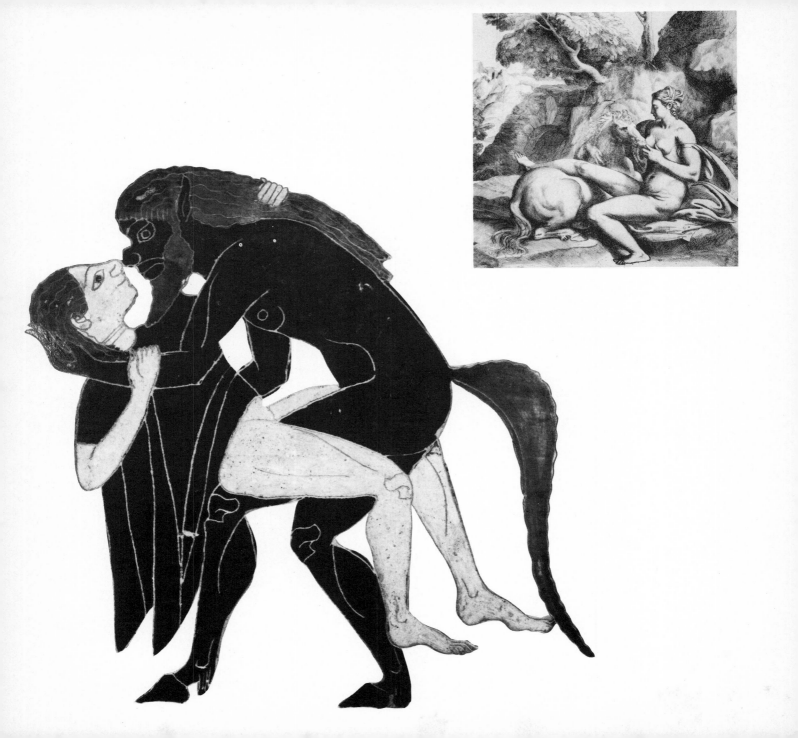

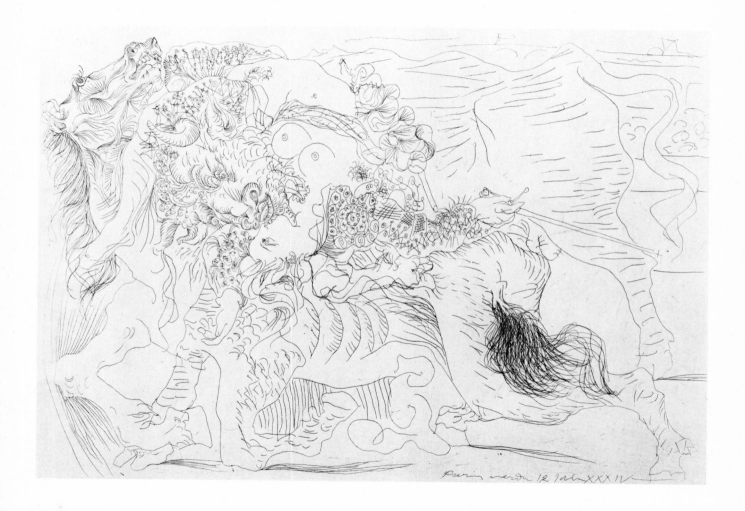

 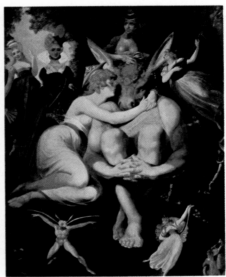

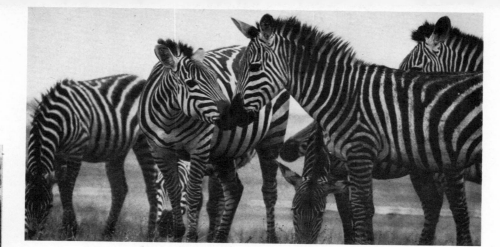

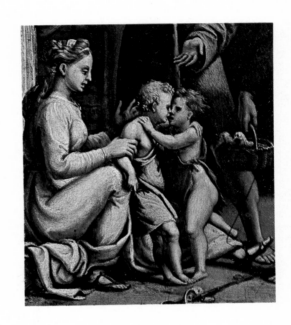

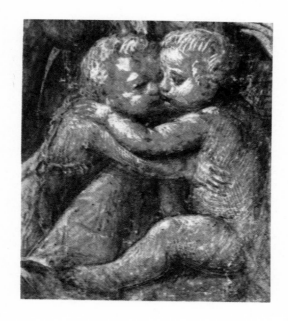

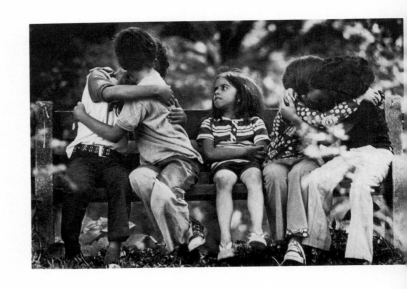

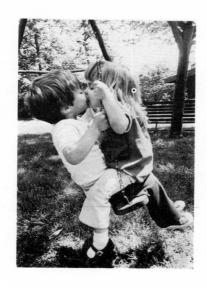

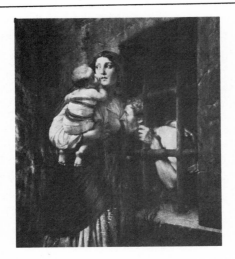
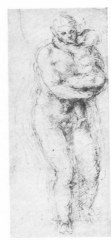

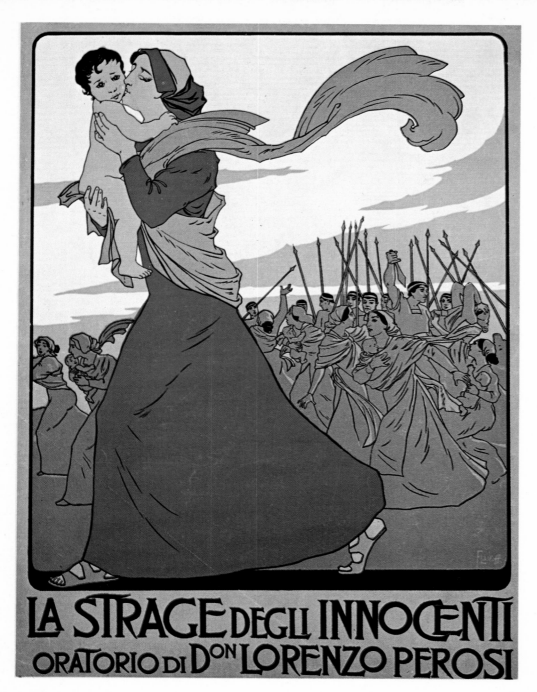

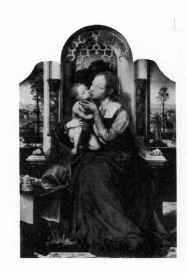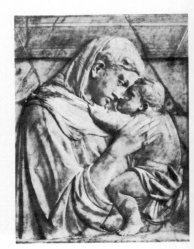

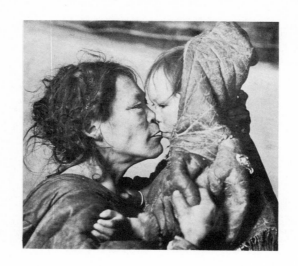

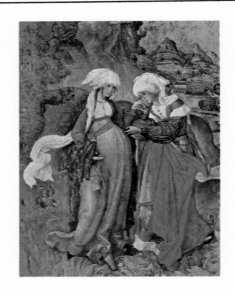

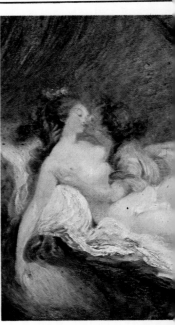

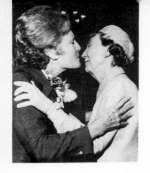

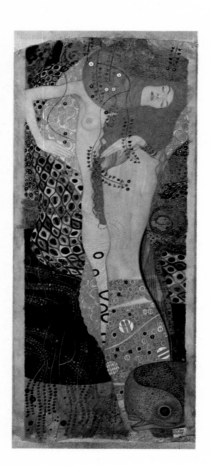

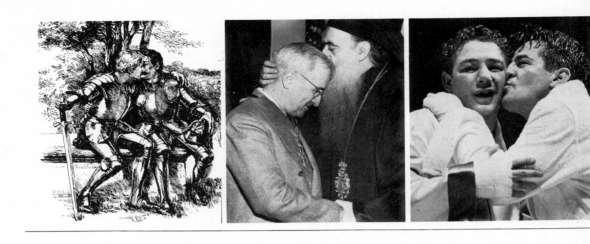

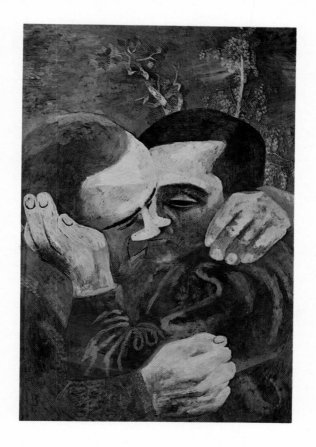

AND DOES BABY GET A NEW FUR COAT?

SHE'S KIND TO DUMB ANIMALS

OLD YOUNGSTER

For goodness sake, man, be your age!
Forget your young ideas!
Why can't you leave this betting stuff
To guys just half your years?

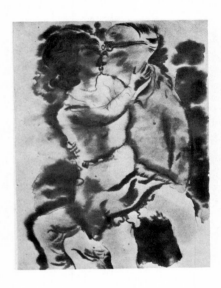

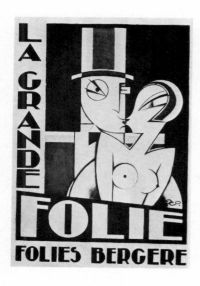

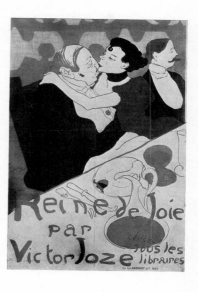

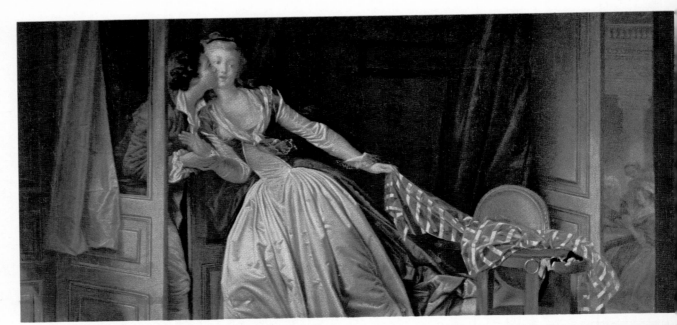

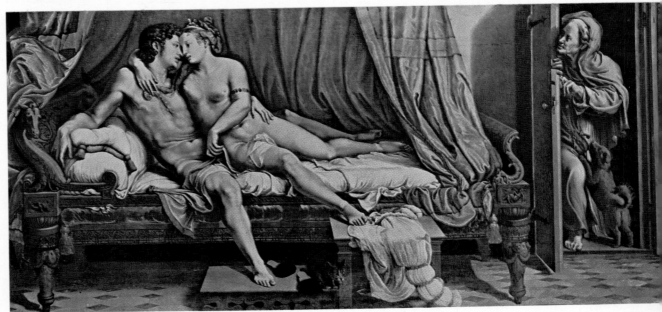

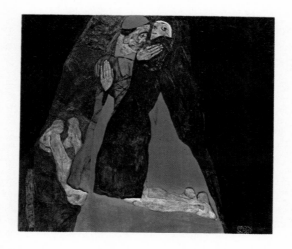

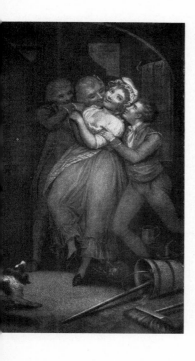

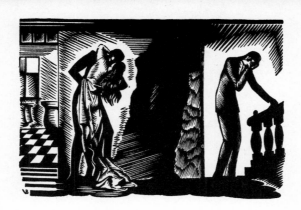

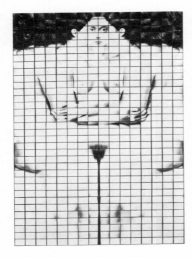 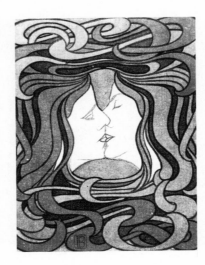

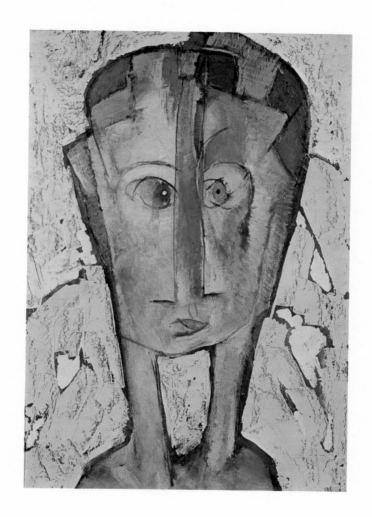

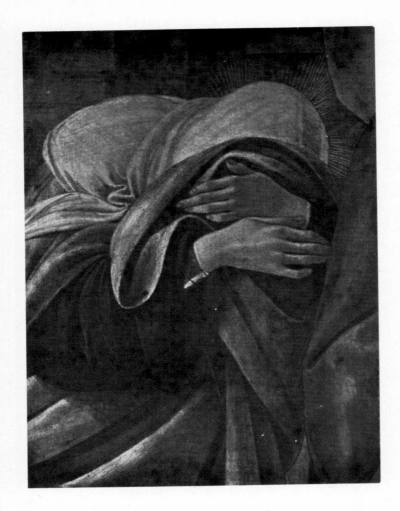

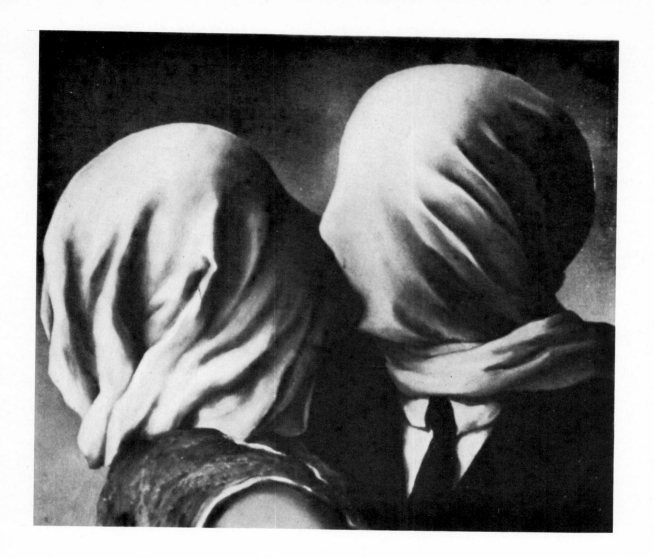

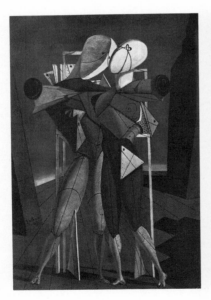

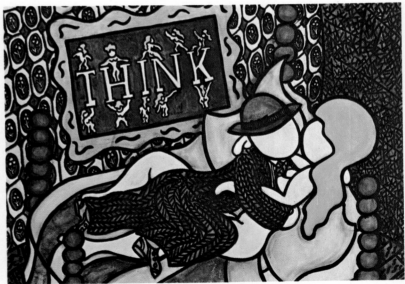

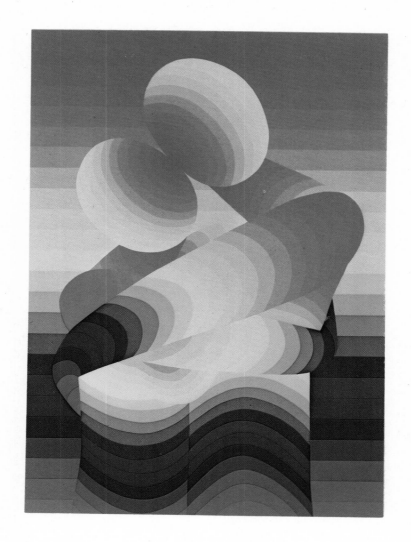

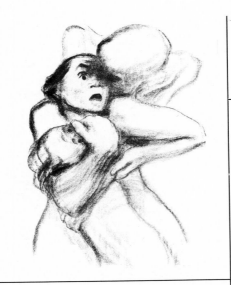

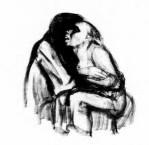

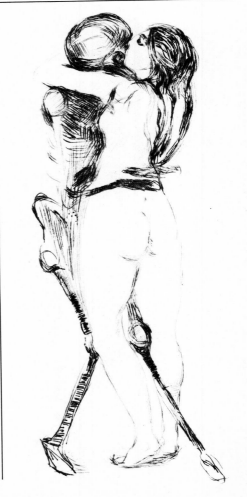

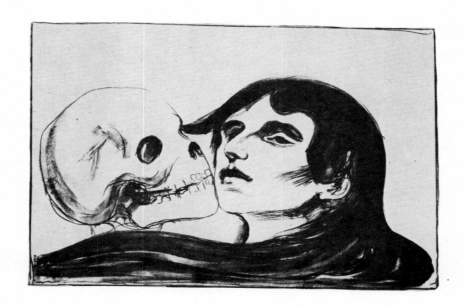

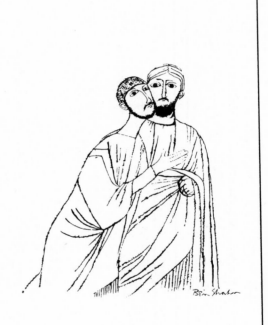

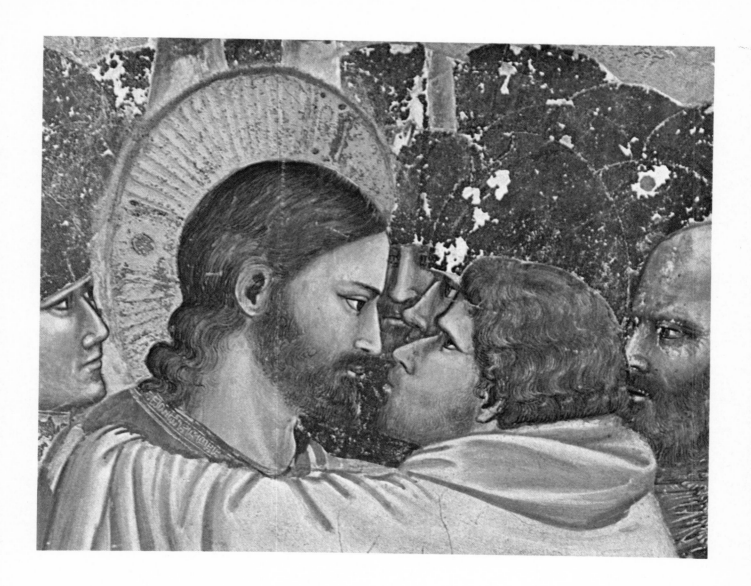

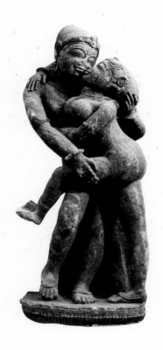

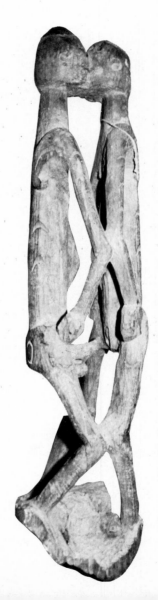

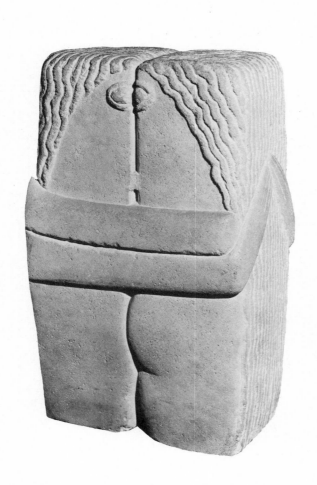

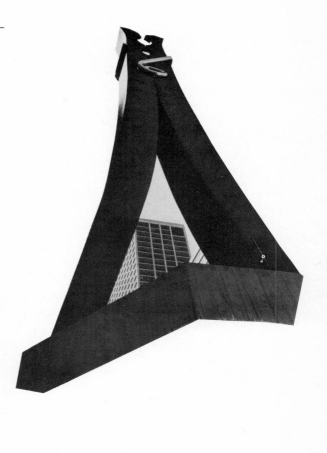

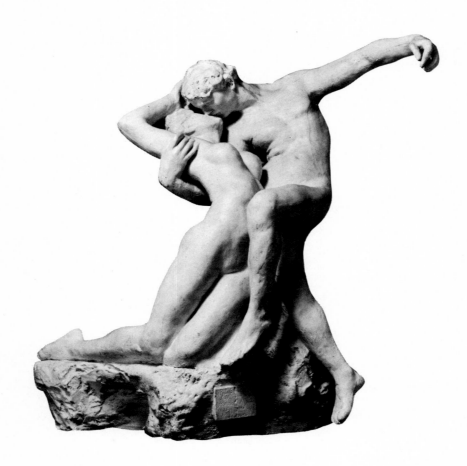

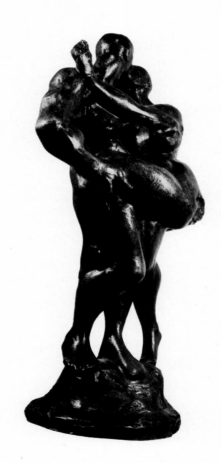

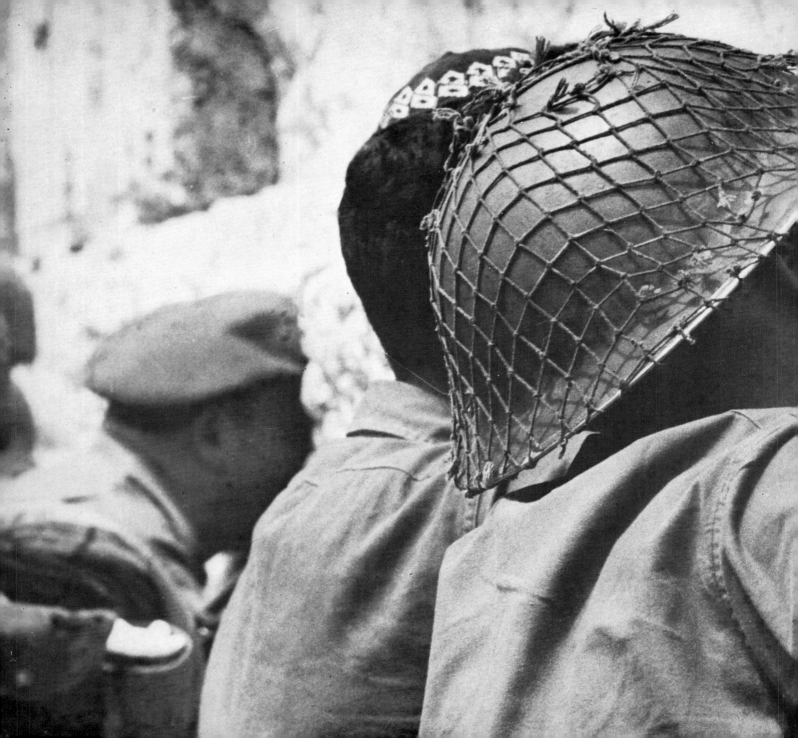

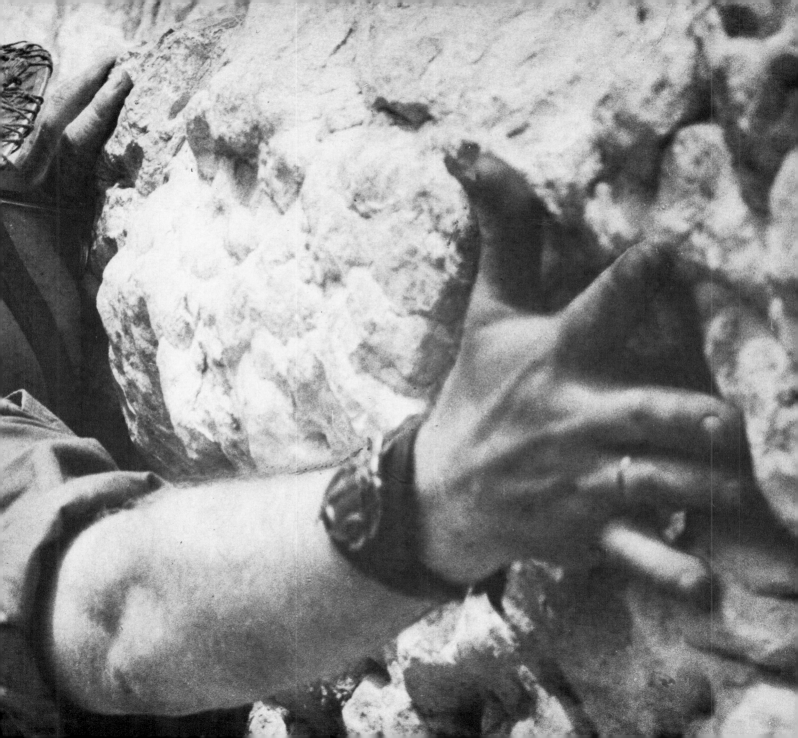

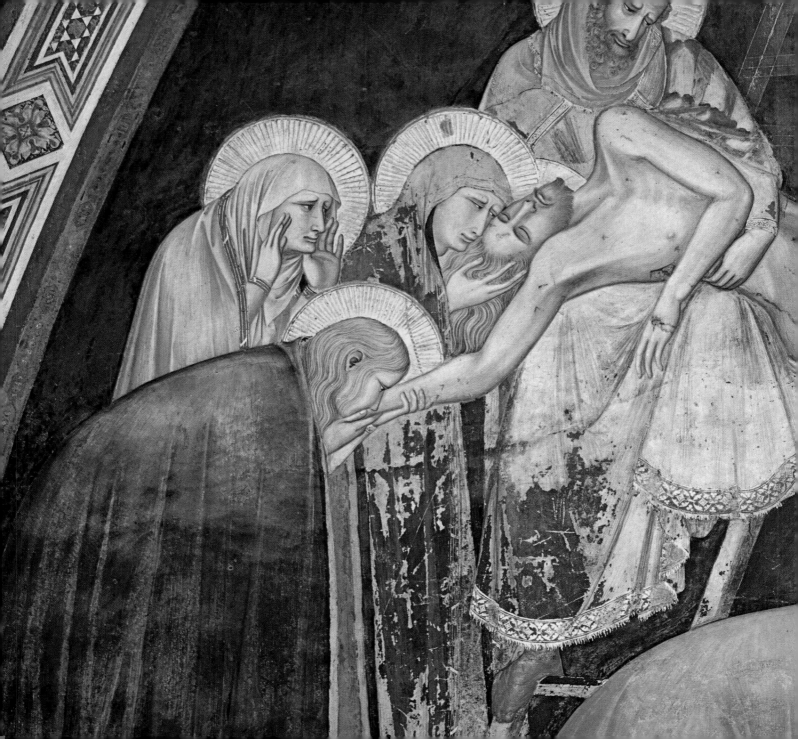

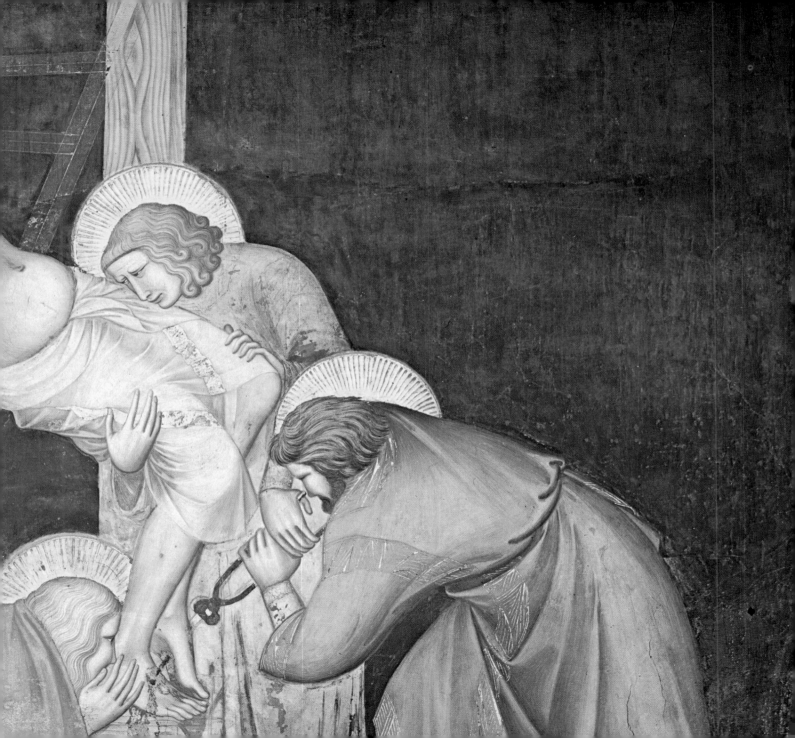

 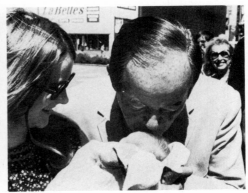

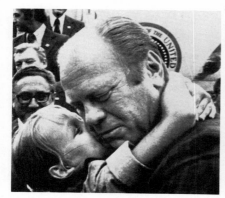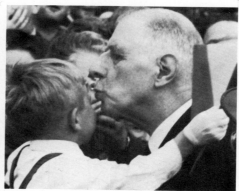

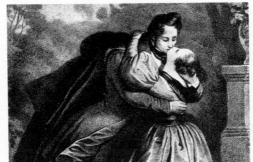

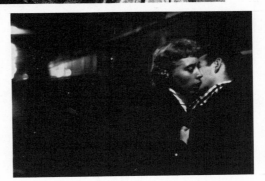

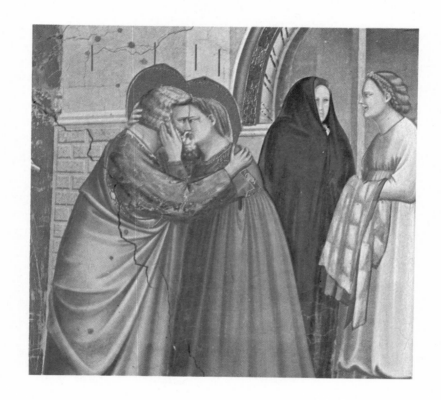

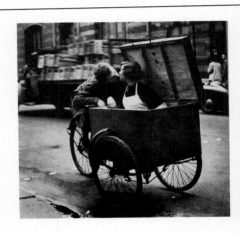

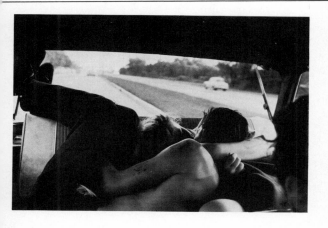

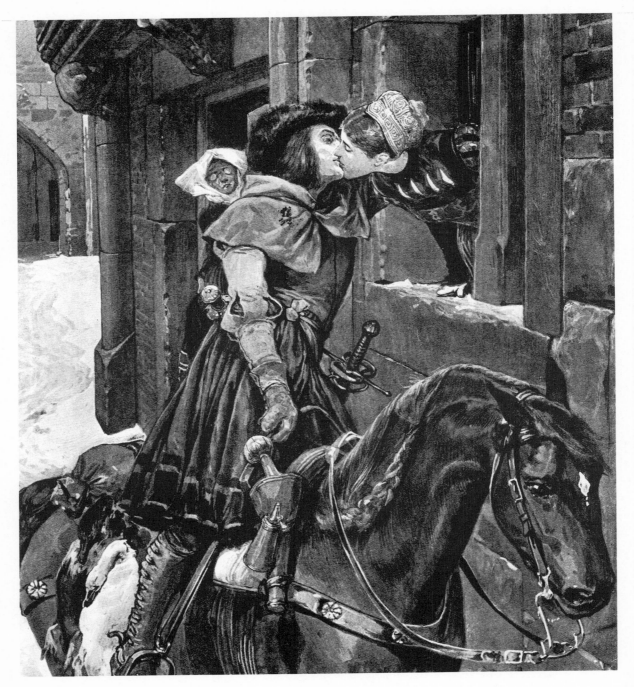

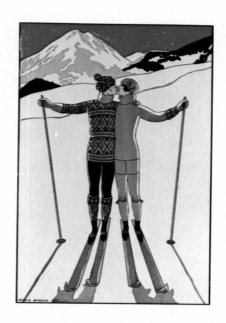

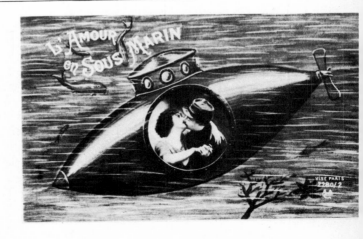

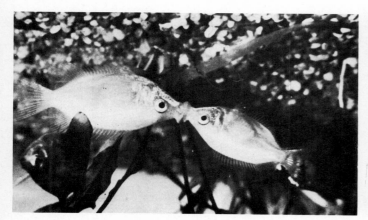 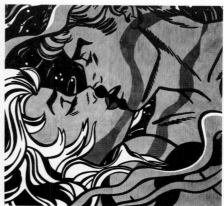

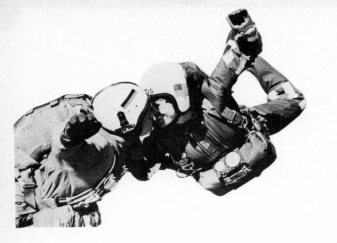

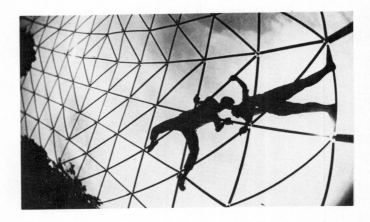

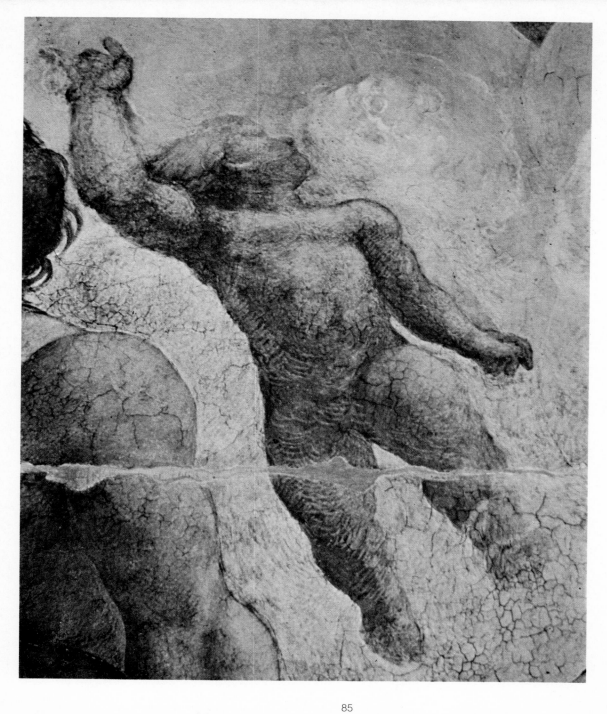

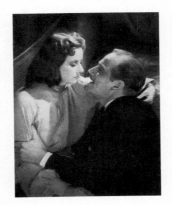

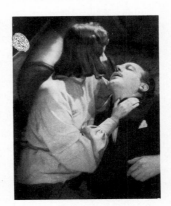

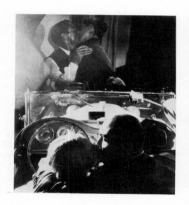 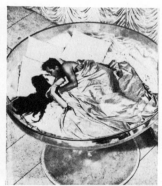

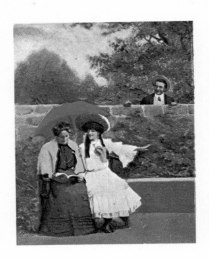

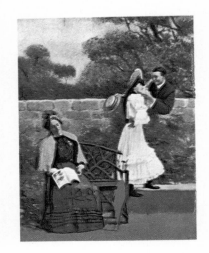

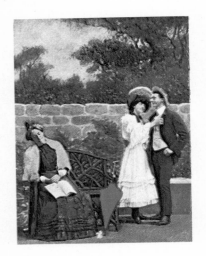

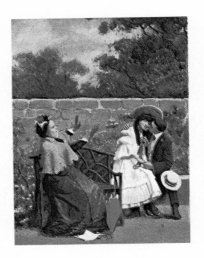

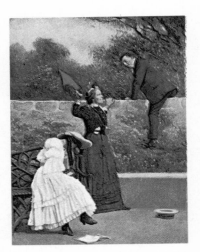

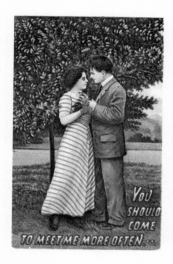

YOU SHOULD COME TO MEET ME MORE OFTEN...

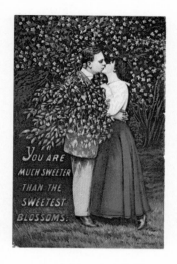

YOU ARE MUCH SWEETER THAN THE SWEETEST BLOSSOMS.

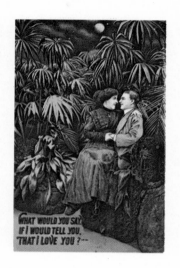

WHAT WOULD YOU SAY IF I WOULD TELL YOU, THAT I LOVE YOU?--

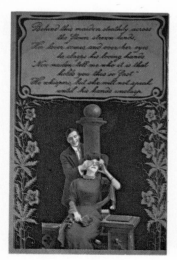

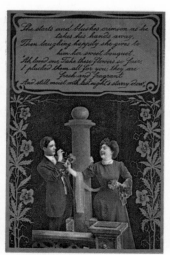

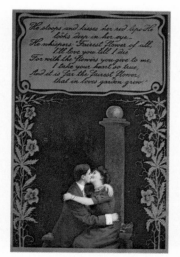

 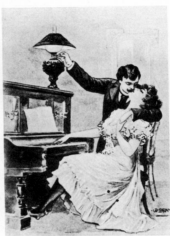 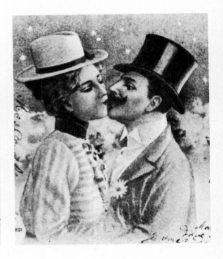

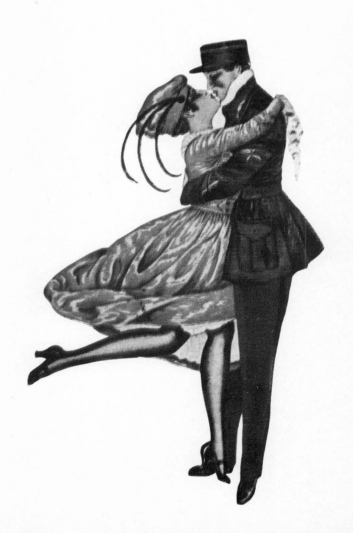

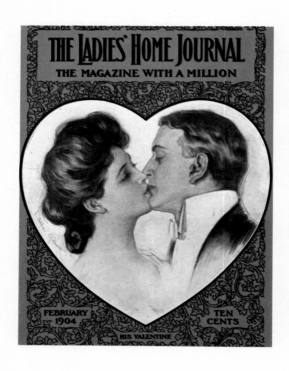

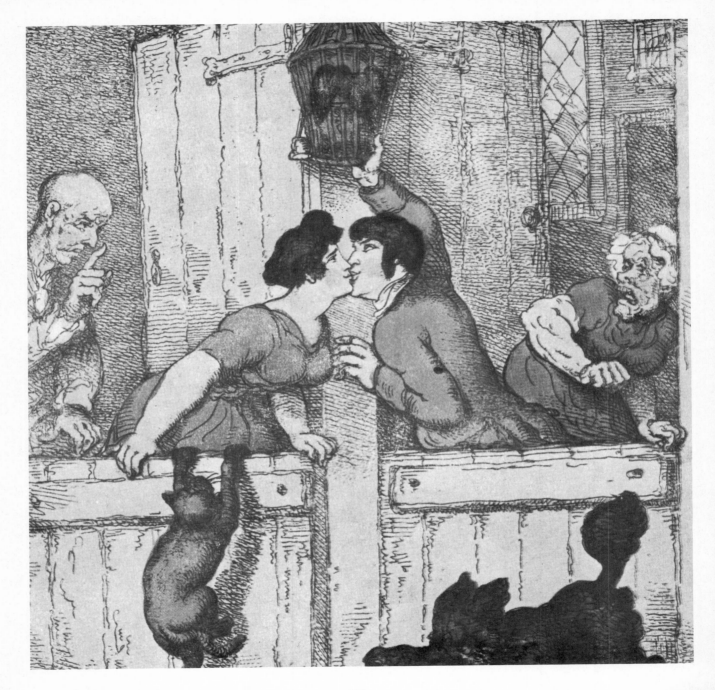

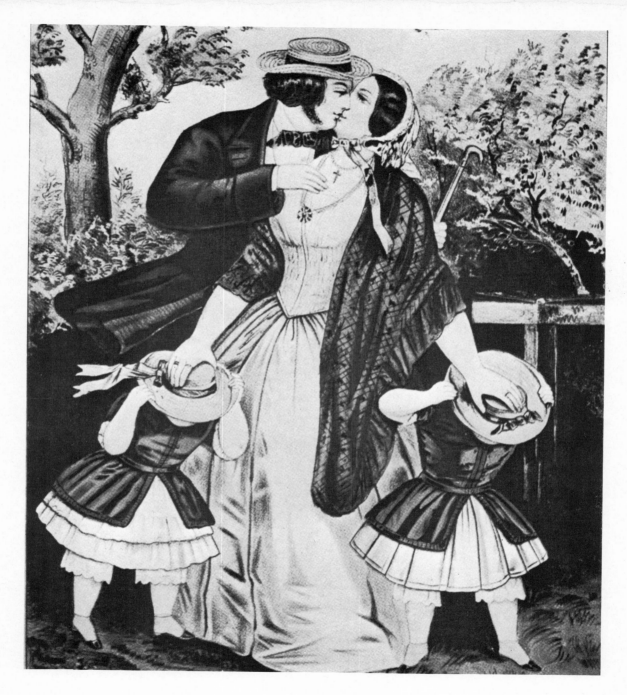

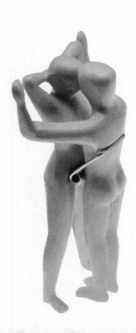

The sound of a kiss is not so loud as that of a cannon,
but its echo lasts a great deal longer.

—Oliver Wendell Holmes

List of Illustrations

25. Etching, Pablo Picasso. © SPADEM, Paris, 1976.

26. Shunga woodcut, Suzuki Harunobu, mid-18th century.

27. Shunga woodcut, Kitagawa Utamaru, late 19th century.

28. Gouache, Nepal, 18th century. Collection, Ajit Mookerjee, London.
Gouache, Kangra, c. 1800. Collection, Ajit Mookerjee, London.

29. LOVE MAKING, Raoul Dufy, woodcut, 1912. Collection, The Museum of Modern Art, New York; purchase fund.

30. EROTIC GROUP, terracotta, c. late 2d century B.C. Delos Museum. Photograph courtesy of the Institute for Sex Research, Inc., Bloomington, Indiana.

31. THE LOVERS, Joan Miró, pastel, 1934. Philadelphia Museum of Art; the Louise and Walter Arensberg Collection. Photograph by Alfred J. Wyatt.

32. Detail from a Greek water pot, late 6th century B.C. Kunsthistorisches Museum, Vienna.
SATURN AND PHILYRA, Guilio Bonasone, engraving. The Metropolitan Museum of Art, New York; the Elisha Whittelsey Fund, 1959.

33. TAUROMACHY I, Pablo Picasso, etching, 1934. Collection, The Museum of Modern Art, New York; acquired through the Lillie P. Bliss Bequest.

34. THE KISS, Will Bradley, poster, 1896. Photograph courtesy of Scala New York/Florence.
TITANIA, BOTTOM, AND THE FAIRIES, Henry Fuseli, oil, 1793-94. Kunsthaus, Zurich.

35. Illumination from a Persian manuscript, Maragha, 1298. The Pierpont Morgan Library, New York.

36. Sheet music cover, 1908.
Photographs by United Press International.

37. Photograph by Ian Berry/Magnum.

38. ADORATION OF THE SHEPHERDS (detail), Giulio Romano, oil. Photograph courtesy of Scala New York/Florence.

39. VIRGIN WITH THE CHRIST CHILD AND ST. JOHN BAPTIST (detail), Bernardo Luini.

40. Photograph by United Press International.

41. Photograph by United Press International.

42. MOTHER AND CHILD, drawing, Ben Shahn, 1953. © Estate of Ben Shahn.

ROMAN CHARITY, Jules Lefebvre, Salon of 1894. Melun Museum, Melun, France.
THE VIRGIN AND CHILD, Michelangelo, drawing, c. 1560 ©Trustees of the British Museum.

43. Theater poster. Photograph courtesy of Scala New York/Florence.

44. THE ENTHRONED VIRGIN MARY, Quinten Massys.
THE PAZZI MADONNA, Donatello, 1420-22.

45. ESKIMO MOTHER AND CHILD, photograph by Richard Harrington.

46. Detail of the altarpiece of Selmecbanya, Hungary, c. 1506.
Princess Margaret and Queen Elizabeth, photograph by United Press International.
THE TWO LOVERS, Jean-Honoré Fragonard, oil. Collection, Leopold Rey. Photograph courtesy of André Held, Ecublens.

47. FRIENDS, Gustav Klimt, 1904-7. Osterreichische Galerie, Vienna.
Pat Nixon and Mamie Eisenhower, photograph by United Press International.

1932-34. Lachaise Foundation; courtesy of Robert Schoelkopf Gallery.

70. Soldier kissing Western Wall in Jerusalem, photograph by Gilles Caron. Courtesy of Liaison Agency, New York.

72. DESCENT FROM THE CROSS, Pietro Lorenzetti, fresco. Lower Church of S. Francesco, Assisi. Photograph courtesy of Editions d'Art Albert Skira, Geneva.

74. Fidel Castro and Hubert H. Humphrey, photographs by United Press International.

75. Gerald Ford and Charles DeGaulle, photographs by United Press International.

76. GOOD-BYE IN THE MORNING, L.P. Debucourt, engraving, 18th century.
THE RETURN, A. Deveria, lithograph, 19th century.
COUPLES, photograph by Ernst Haas/Magnum.

77. THE MEETING AT THE GOLDEN GATE, Giotto, fresco. Scrovegni Chapel, Padua.

78. THE KISSING COUPLE, photograph by Robert Doisneau. Courtesy of Rapho/Photo Researchers, New York.

79. THE GANG, photograph by Bruce Davidson/Magnum.

80. A CHRISTMAS FREEBOOTER, R. Caton Woodville, drawing.

81. WINTER, George Barbier, calendar illustration, 1925.

82. French postcard.

83. Photograph by United Press International.
WE ROSE UP SLOWLY, Roy Lichtenstein, oil and acrylic, 1964. Hessisches Landesmuseum, Darmstadt, Germany; Karl Stroher Collection. Photograph courtesy of Leo Castelli, New York.

84. Photographs by United Press International.

85. FLYING PUTTO KISSING ANOTHER PUTTO, Antonio Allegri Correggio, fresco, early 16th century. S. Giovanni Evangelista, Parma.

86. Greta Garbo and Melvyn Douglas in *Ninotchka*. From NINOTCHKA, edited by Richard J. Anobile, a "Film Classics Library" title which recreates this famous motion picture by means of more than 1,500 frame blow-ups and complete dialogue. © 1975 Darien House, Inc. Published by Universe Books and Avon Books, and in England by Jupiter Books and LSP Books.

87. Photograph by United Press International.
Shirley MacLaine and Robert Mitchum in *What a Way to Go*.

88. Postcards from the collection of Carol Wald, New York.

89. Postcards from the collection of Carol Wald, New York.

90. "Courting Couple" courtesy of the General Research and Humanities Division, The New York Public Library, Astor, Lenox and Tilden Foundations.
French postcard.
German postcard

91. French postcard.

92. COUPLE, photograph by Miriam Friedman.

93. Magazine cover from the collection of Carol Wald, New York.
From advertisement by Nikasinovich for Guerlain lipstick and nail polish. Courtesy of Guerlain S.A., Paris.

94. NEIGHBOURLY REFRESHMENT, lithograph.

95. KISS ME QUICK, lithograph, Currier & Ives.

96. X-RATED PAPER CLIP. Photograph courtesy of Bloomingdale's, New York.